AUTHENTICITY IS A CON

PROVOCATIONS

AUTHENTICITY IS A CON
PETER YORK

SERIES EDITOR:
YASMIN ALIBHAI-BROWN

Biteback Publishing

First published in Great Britain in 2014 by
Biteback Publishing Ltd
Westminster Tower
3 Albert Embankment
London SE1 7SP
Copyright © Peter York 2014

ISBN 978-1-84954-787-1

10 9 8 7 6 5 4 3 2 1

A CIP catalogue record for this book is available from the British Library.

Set in Stempel Garamond

Printed and bound in Great Britain by
CPI Group (UK) Ltd, Croydon CR0 4YY

Contents

You Make Me Feel (Mighty Real)

You make me feel mighty real
You make me feel mighty real
I feel real
I feel real
I feel real
I feel real
Huh

– Sylvester James, 1978

'Sincerity – if you can fake that,
you've got it made.'

– George Burns, 1952

Introduction and acknowledgements

THIS IS A series just made for a medium-sized but deeply felt rant. That suits me. I've known – for, oh, about ten years, but particularly after the 2008 crash – that I had to write about authenticity. It's been banging its way out of my head over the last year because I was hearing people talk about authenticity on an ever more constant basis and it made me feel rather shouty. It was partly how they used the word and partly the people who were using it.[1] Something was going on.

[1] The *Oxford English Dictionary* says 'authentic' is: 'The fact or quality of being true or in accordance with fact; veracity; correctness. Also accurate reflection of real-life verisimilitude.' This is a definition which 2014 users disregard as too boring. They take it to mean true to your feelings; true to some aesthetic; true to some arbitrary decision.

It meant I had to get in touch with my deepest, most *elemental* feelings about the idea.

Readers who've done PPE, or just either Politics or Philosophy, will notice I don't spend much time on politics. This is because there's a mass of stuff on political authenticity already and practically none at all on academic philosophy, even though there's a huge historic philosophical debate and a massive literature about authenticity. I don't really know my Hobbes from my Heidegger and I'm not going to fake it. Instead, I've tried to show where the people boosting the 2014 authenticity vibe are coming from and where I stand about it all.

I'll take you to my own fountainhead (when anyone references that terrible old nutjob Ayn Rand,[2] you know more than you'll ever need to about them). I'm not exactly transparent – a word with a parallel life to authenticity that keeps rather sinister company – but God knows I'm trying.

I've had lots of help. I originally tuned into 'foodie'

2 Ayn Rand: novelist (1905–82); wrote *The Fountainhead* (1943); constant
inspiration of all Bongo right-wingers.

talk from reading Ann Barr and Paul Levy's marvellous *Foodies* (*The Official Foodie Handbook*, 1984), from 'foodist' people I've met with Henrietta Green, and from Adrian Gill's clever locutions about how food ideas arrive in our lives at the front of his *Sunday Times* reviews.

Alice Sherwood convinced me I shouldn't even touch 'big P' philosophy, simply by knowing the territory so well herself when we talked about her own 'F is for Fake' project.

Juliette Jackson and Maxine Ostwald filled in a lot of the blanks and Sally-Ann Lasson helped me through a night out in Shoreditch (bare brick and peak beard).

Michael Bracewell talked me through authenticity in popular music and I chewed heavily on Deyan Sudjic's and Stephen Bayley's ideas about design (in Stephen's case, the design of his life too!) And thank you, Iain Dale, for giving me this platform, and my darling editor, Yasmin Alibhai-Brown, for suggesting me for it. As for the rest, I'm so not worthy.

Part I

My journey, their journey or the manufacture of authenticity

I N LUNA & Curious, a 21st-century shop selling what used to be called 'notions' – bits and bobs, little books printed by local presses, accessories and artistic china – on Calvert Avenue, E2 (i.e. Shoreditch), the killer product is 'honest man's beard oil'. This is the right place for it, because Shoreditch in late 2014 is top for beards: it's probably got the highest beard count in the Western world outside a Birmingham mosque. There've been a lot of newspaper pieces and blogs recently about 'peak beard', the idea that the

fashion for beards among young men in the creative industries has peaked, because it was getting altogether too common – too many men had them (and some of them were the wrong men). My friend (cartoonist Sally-Ann Lasson) and I are bare brick- and beard-spotting; the beard flow in the streets of Shoreditch is as good as ever. Mockery in the *Telegraph* doesn't seem to have the driven the locals to panic depilation.

On Redchurch Street, the Hostem men's clothes shop is very dark and disciplined. It sells all those we're-not-Bond-Street brands – the Japanese ones, the Belgian ones, the ones with the restricted palette of black, white and grey. It's expensive stuff, and designer in the literal sense that the target market has to be among men trained in that peculiar way of seeing. On the top double-height storey (they own an old mini-block, the outside brick painted dark grey), there's an amazing floor – herringbone parquet in shining dark grey. We're peering at it trying to work out what it's made of.

Give up.

We ask the (bearded) assistant.

It's stainless steel! Stainless steel specially cut into parquet blocks. Later I check out the cost: it's about £600 per square metre. You might as well paper the floor in £50 notes.

Over the last twenty years and more, Shoreditch (the media name for the new East End – Hackney, Hoxton, wherever) has gone from artist colony – our own little Montmartre for our own little gang of 1997 Young British Artists (YBAs)[3] – to a large commercial theme park. Or, as I described it in *GQ*:

> Hoxton, the fashionable artistic quarter of the East London Borough of Hackney (No. 3 most deprived borough in Britain), is the most invented world imaginable, summoned up from nothing by the voodoo forces of the contemporary art market, clever-end property developers and media in fewer than ten years … it's Shangri-La, an enclosed world where nobody ever has to grow up.[4]

3 The Royal Academy's *Sensation* exhibition.

4 *GQ*, 2003.

For 'invented', read inauthentic. Whatever its origins, Shoreditch couldn't be more calculated, more of a series of planned investments. It's a developer's asset class and has developed astonishingly fast. In, say, 1999 there weren't that many shops, and those that were there were still mostly low-investment, wacky one-offs – oh so very art school.

But now you have places like Hostem, home of the stainless steel floor, which is a menswear shop fixed up as an art gallery. They call it a 'conceptual menswear destination'. Hostem prices are really quite something: the Rick Owens Stoogers Biker Long Edition,[5] a sort of zipped leather jacket (note the 'edition'), is £2,790; the MA+ Back Zipped Short Extra Heel Boot (with big turned up toes) is £1,390. They're called 'pieces', which means 'limited edition' will be lurking somewhere. These prices put them at the very top of the Bond Street/Savile Row ready-to-wear range.

Shoreditch is a registered London attraction now. It

[5] Rick Owens Stoogers Biker Long Edition: 'A new hybrid of the Stoogers jacket. Mid-weight calf leather that is soft to touch, combined with dropped semi-attached ultra-soft thick cashmere lining.'

has 'bridge and tunnel'[6] visitors from outer Essex and there are even tour guides – just like the Tower of London. There are familiar shops from the West End, and everywhere else, opening an edgy embassy, a funky flagship – the same shops you see on Portobello Road and the King's Road. Multiples that can afford to pay good rents.

The trademark look in Shoreditch is applied authenticity. It's a thing of surfaces; anti-bling surfaces that actually cost much more than the gold and glass and shiny marble of mainstream bling. Shoreditch has bare brick walls, reclaimed floorboards and poured concrete floors; flax and hemp and string and brown paper (to go with the beards and the bikes). These surfaces, originally cheap and utilitarian, basic and sort of good taste and engaging, are now all as expensive as you can get. This standard cladding of realness is now glued and screwed to every bit of Shoreditch. It's been brought in, of course. Did you know you can buy brick veneer by the yard now?

6 'Bridge and tunnel' is the snobbish Manhattanite term for people outside the island – typically from New Jersey – who arrive via bridges and tunnels.

The beard thing is something else again. Academics have devoted acres of text to the beard revival. There are a thousand reasons to be a mainstream beard adopter: guy things, from protesting against assertive women to comfort and time-saving. But in the first instance (back in, say, 2005/6-ish), it was a retro aesthetic, a 'look'. Call it Edwardian Explorer Poet for argument's sake, it is something culled from old pics and dead men – men as impossibly unlike the pioneer metrosexual beard boys of 2005/6 as you could possibly imagine. Men who'd never had an iPad or L'Oréal Men Expert 24Hr Hydrating Balm in their bathroom cabinet (indeed, never even had a bathroom cabinet). The beard – the ideal 21st-century tone is russet – is another modern retro surface as assiduously grown and trained as an RHS best-in-show plant.

In Labour and Wait on Redchurch Street, the campaign against the modern world could not be clearer. They sell everything you'd have seen in the 1910 house. Plain things made of hemp, bristle, enamel and tin. Every sweet, modest servants' hall thing you can imagine, re-priced for now. All of it rendered completely redundant

by the glorious invention of injection-moulded plastic, of Pyrex and Teflon and Formica. Sally-Ann buys a little rope table-whisk affair. It's made, it turns out, in very small numbers by a very old person who's been knighted for his services to rope. All praise that back-story.

There's an established route for places like Shoreditch. It's charted in Richard Florida's *The Rise of the Creative Class* (2002).[7] Florida showed how pioneer artists – real ones with no money – go down like canaries in mines to settle in the cheap, interesting areas. If they survive, they're followed in the next wave by early adopters with well-paid creative industries jobs. Then you get the bankers, or whatever kinds of rich people want to live there or develop the hell out of it. By then the artists are usually long gone.

The thing about the Shoreditch development was just how fast it went this century and just how much money's gone in there. It's looking really like the Lower West Side in New York, which has all the same shops as Fifth Avenue or Madison, but with more bare brick

7 Published by Basic Books.

and reclaimed board. If you told me Shoreditch had been planned from day one by a couple of developer boys from Camden in Richard James's[8] Savile Row 1998 Regency buck suits, I think I'd believe you.

My day with Nige

The Nigel Farage look is a little earlier – mid-period Leslie Phillips perhaps – but powerfully resonant for a certain constituency.

Late last year I found myself sitting next to Nigel Farage, king of UKIP and Man of the People, at a jolly lunch in London – a prelude to him being interviewed on stage.

Lunch was a mixed grill, that most trenchermanish of meals (I could eat it every day), involving fried egg, bacon, sausage, a sliver of steak and no veg beyond the bright tomato,[9] plus a statutory glass of kitchen red to your right.

8 Richard James is a pioneer of the New Savile Row look favoured by '90s faces – and me.

9 Who'll be first to say the tomato's not a vegetable?

During an interesting conversation about his parallels with Pierre Poujade, the French 'blood and soil' popular leader of the '50s, Nigel said Poujade had done a lot for France and so he thought it wasn't too unflattering a comparison at all. I was watching Nigel's plate very closely, and his glass. He dealt with his mixed grill – the kind of unponcy thing you'd imagine he liked – most fastidiously. Downright daintily, practically metrosexually, you might even say. He flayed the sausages, but didn't really eat them, and he trimmed all visible fat from his bacon. His red wine remained untouched (I'd downed mine and refilled).

Then Nigel said, 'I'm nipping out for a fag.' Good idea, Nige. So I followed him, after a discreet interval. He wasn't outside, but halfway up the street, and he wasn't smoking, but bellowing instructions into his mobile. Directly outside, however, was one of those men with a neck as wide as an elephant's foot. It was Nigel's minder, who kindly gave me a cigarette and told me about his security work with ethnic artistes in the music industry.

When Nigel returned and went up to the stage, he

took his wine with him. He glugged it ostentatiously while answering highly selected questions from the faithful, independent shopkeeper types ('I feel we're being ruled from Brussels/Strasbourg now, Nigel – do you agree?' kind of thing).

Nigel Farage, whatever you feel about his politics, is widely admired as the authentic voice of something – the Home Counties' saloon bar possibly – and his style is always contrasted with the careful, scripted, professional 'lifer' politicians, people from the Westminster Village, the Club, the London political class and all that. Nigel, so they say, shoots from the hip, channels the people, tells it like it is. Yet – and I say this in a very caring way, a manly and hygienic way – I felt he'd been just that little bit clever, for someone quite so authentic. I felt I'd been in the political kitchen, and things looked different there.

But now we live in a magic world where the old meanings just don't apply. When politicians wrap themselves in the mantle of authenticity, what's the equivalent of carbon dating? (Joe Biden's hair and teeth?) Can you catch them telling outright definable lies in a world

where, as Reagan's political strategist Richard B. Wirth-
lin said in a position paper, 'People act on the basis of
their perceptions of reality; there is, in fact, no polit-
ical reality beyond what is perceived by the voters.'[10]
The crassest old fakes, like Reagan, often look charm-
ing now; they've transitioned to collectibles.

My mother, who was all heart and bien pensant Lon-
don liberal sentiment, nonetheless loved Hermann
Goering, top Nazi, for his comic sayings, particu-
larly: 'When I hear the word culture, I reach for my
Browning.'[11] She felt it expressed her own feelings about
some of our NW3 neighbours.

When I hear the word 'authentic' I reach for my
Browning. I have a major scam alert. The idea of authen-
ticity – deliciously vague, as ubiquitous as Starbucks
now – has hit the spot with a wide variety of chancers
and boosters at pretty much the same moment. Post-
crash, every charlatan going was re-tooling 'the scam'
and its language for a changing market.

10 'Reagan for President Campaign Plan', 29 June 1980.

11 The Browning pistol, an American invention of 1935.

'Authentic' is a word that grates, reminding me of the fast one about to be pulled, the value about to be added, the tosh about to be talked, the snobbery in waiting and the insecure micro-connoisseur at your elbow. For New Age, motivational, change-your-life speakers, marketeers, music entrepreneurs, foodies and design bugs – and, yes, politicians too – the idea of authenticity is nicely elusive, and very now.

I should say here that I'm one of the most palpably inauthentic people you'll ever meet. I'd rather not know about my immortal soul, or my true self. Things change. I'm the kind of person whose evident over-dressed ponciness and mannered chat provoke people into a slow burn of irritation (as Tom Wolfe described a preppie reacting to one of his white-suit outfits in the Hamptons: 'Like a fire in a sofa'). Mature *Guardian* writers in their sober grey T-shirts and black jeans can sense my over-dressed, overly obsessed inauthenticity in seconds; they can smoulder at the horrible conceits I come out with, the gruesome marketing speak, my enduring enthusiasm for modish trivia.

Rather annoyingly, that doesn't happen quite so

often now. It used to be so easy to get a rise out of those types – indeed, it's still easy enough to get a bad review from *The Guardian* – but they've learnt over the years. They've learnt some of the irony canon, the 'guilty pleasures' and popular culture tropes, although all a little clunky and a little late. They've learnt something about micro-connoisseurship as their areas gentrified and got smarter shops, although micro-connoisseurship – the joy of cheese – is actually 21st-century mainstream marketing posing as its opposite, eternal verities. I love *The Guardian* and I want it to be there forever, but some of its writers do have issues.

I find personal inauthenticity gives you more room to move in the real world. I don't always say what I mean. I'm not exactly transparent – one of the most gloriously inane terms of the corporate and personal therapy age – and I think you should keep the truth for the best, for when it's really needed.

And I don't share. I don't like the cod-empathy of misery memoirs and daytime TV. And this isn't just don't-frighten-the-horses Britishness. I'm a baby boomer brought up in a liberal world, with Psychobabble Central

just a shot away.[12] The call to throw off the chains of repression, sublimation and all that other directed behaviour was the constant murmuring of my milieu, and Blake's 'Damn braces: Bless relaxes'[13] was everyone's watchword. But it sounded so boring to me, like not playing with a full deck and not having much fun.

My idea of a full deck, using all the best historic things going, meant artifice piled on artifice, glorious conceits, everything in the landscaped garden. Subscribe to easy ideas of authenticity and you cut yourself off from all that in favour of a more wholegrain life. (Did you know wholegrains are part of the fashion cycle now? Every eighteen months there's a new, better wholegrain discovered and the old ones are retired as hopelessly out and suburban. So don't invest in quinoa, it's really peaked.)

The wages of inauthenticity are conflict and misery, so the conventional wisdom goes. But if you'd just be yourself then a glorious dawn would follow – it's one

12 The Tavistock Institute in Swiss Cottage.

13 From William Blake's *The Marriage of Heaven and Hell* (1790).

of the favourite images of the Human Potential Movement, which likes corny images. But if everyone really did that, nothing would ever get done. People searching for their personal truth can't be arsed to build Crossrail.

But I believe a bit of measured inauthenticity, some flattery, some white lies, make things work and cheer everyone up. And the trade-off between the personal and the collective is the basis for anything worth having, certainly for any political progress. The personal is political – who could forget that as a useful slogan? – but 2014 micro-identity, 'me' politics isn't what that meant at all. (And no man is an island, entire of itself, while we're about it.)

At this sixteenth-century point you'll be murmuring that constant Shakespearean tag everyone knows, 'To thine own self be true', always roped in to support the authenticity lobby. More precisely it's *Hamlet*, Act I, Scene iii, where Polonius says:

> *This above all: to thine own self be true,*
> *And it must follow, as the night the day,*
> *Thou canst not then be false to any man.*

Polonius! I'd forgotten it was Polonius, the prosy old blowhard, hardly an example to us all. That changes everything, of course. It could have been written as every inch the 'My Way' platitude it's become, typical of a character notably short on self-knowledge.

Readings of authenticity have shifted over the years. Previously it was a combination of a vague minority snobbery – the Elizabeth David kind – with a crisp logical application in authentication, all yoked to a massive back-story of academic philosophy if you were bothered (particularly Heidegger, him of the fancy Bavarian get-ups and Nazi sympathies). But now it's in a 21st-century and post-crash overdrive, where its meaning has changed. It's become the absolute favourite 2014 word of shysters and chancers; of political consultants and crisis managers; of PR and marketing types like me; of motivational speakers and life coaches dealing with 'human potential'; of people who think 'I'm so worth it'; and of practically every other fruit loop with a YouTube account – people with only the vaguest idea of authentication and none at all about the philosophical back-story. They think it's about them. It is now.

The 'me' generation and the rolling thunder of authenticity

I've always loved self-help books. The 'how-to' was one of the major discoveries of my first time in America (meaning New York, of course). Those gorgeous long-gone Fifth Avenue bookshops – Doubleday, Scribner, Brentano's and the rest – were already merchandising their books in the late '70s. They were out on tables, and bestsellers were stacked face-on. They made it fun. No matter how grand the Robber Baron library design, there was always a big display of self-help books. How to do practically anything, conquer your fears, become a millionaire, or be redeemed from practically anything. They were full of redemption. I took a suitcase-full of books home that first year, and a copy of *New York* magazine with a piece by Tom Wolfe called 'The "Me" Decade and the Third Great Awakening', where Wolfe described how 'the new alchemical dream is: changing one's personality – remaking, remodelling, elevating, and polishing one's very self … and observing, studying, and doting on it. (Me!)'[14]

14 *New York* magazine, 23 August 1976.

There was nothing remotely like that in thinking Britain then – it was so far up and over Maslow's famous hierarchy of needs as to be practically invisible in Blighty.[15] We had quite enough to worry about, like where the next meal was coming from.

I went to America several times a year after that. I bought *The Serial* – the satire about life in Marin County, California, the positive hub of 'me' land – in 1977. Later, in 1979, I bagged Christopher Lasch's epic *The Culture of Narcissism*, that year's big-worry book, which explained how American expectations had shrunk from Great Society visions to a narcissistic concern with 'me', my health, my happiness and my personal growth. In 1977, I'd written a piece in *Harper's & Queen*, 'You, Me and One', picking up on Wolfe's piece and comparing it with the British '70s mind-set: 'The celebration of me is a party at which the British are all shabby – genteel relations standing

15 The 'Hierarchy of Needs' was defined in 1943 by Abraham Maslow (1908–70). The 'Theory of Motivation' it set out, in pyramid form, explored the changing priorities and patterns of human motivations.

PART I

huffily aloof.'[16] 'One' meant the old British, internal-
ised, we … the collective sense of knowing the form,
not frightening the horses, and all that.

Brits simply weren't there yet, we'd 'never been to
me'.[17] We couldn't afford it then. But in the '80s we
invented our own new money and ploughed through
a fair bit of it for the next thirty years – London has
set out its stall for the global seriously rich for the last
fourteen years – so there's enough business here now
for a raft of therapists and motivators, tummy-tuckers
and tooth-veneerers. Over that period, a variety of new
occupations have achieved critical mass. Since Diana,
Queen of Hearts, 'people like us' (PLUs) have con-
sulted psychotherapists, while other PLUs have *become*
psychotherapists.

Put 'authenticity' into YouTube and an amazing
world scrolls down forever. Many of these talking heads
are, of course, American; most are busking for their own

16 *Harper's & Queen*, February 1977.

17 'I've Never Been to Me' is a song by American pop singer Charlene that was
released in 1977 and re-released in 1982.

tiny store-front churches and want to tell you how to be a better person if you sign up. The majority of them are offering all-purpose help to get your mind–body–spirit alignment nicely set up through authenticity. Others are saying, if you're authentic – and here's how – you can be a better leader, as in CEO, and make masses more money. And other, more gym-rat types, are telling men how to be authentic and charm women into bed: 'Show her a little of your vulnerability.' And then there's a fascinating sub-set for high-spending micro-connoisseurs, explaining how to spot fakes of everything from mid-century modern designer furniture to Prada bags and socially significant sunglasses.

I have to say some of these people look or sound a teensy bit *in*authentic to me. A lot of the women are heavily cosmeticised and the men have very contrived dental configurations and disingenuous little tropes, bits of business with all that 'hey guys' stuff. There are open-neck shirts, stubble and tees everywhere, or the occasional tie pulled down to show a relaxed, unscripted moment. But the most inauthentic part is their message. One – consciousmatrix.com – is offering an on-the-spot

authenticity formula for strengthening your personal whatever. There's a routine. This guy, more designer stubble, white tee under dark shirt – does warm-up exercises:

> Just feel the energy coming into your hands – this is who I am right now. You're planning your cosmic order … this is who I am. Now I hold out the left hand – the receiving hand. This is our authentic selves, this is who we are. Feel this beautiful energy.

He goes on like that for twenty-four minutes! What's the deal here?

What all the therapists – the change-your-life merchants and the motivators – say is that you need to get in touch with your true self; when you do, absolutely everything will click into place, but if you don't, all your relationships and initiatives will founder and you'll hate yourself on a daily basis. The world, they all say, has conspired to divorce us from our authentic selves. 'Society' and family expectations, institutions and media have set impossible standards and pieties that we're all

trying like mad to mimic (there's lots of 'we'; these people are terribly inclusive).

'Only connect to yourself' is the message. Or only *re*-connect. Set your wiring straight. And do those little exercises. Say how you feel – how you really, really feel – and people will relate to you. You'll be so resonant. As they're talking, these insanely confident coaches and spirit guides, gushing enough snake-oil to fill a tanker, and going on for ten, fifteen, twenty minutes, I'm shouting at the screen – 'just tell me your business model!'

One thing almost all these authenticity ramblers share is the astonishing level of generality in which they deal. They'll be standing up there with their props – typically a flip-chart with a lot of important-looking word clusters, a vase of luridly naff flowers, a Buddha head or an Indian fretwork screen – without saying anything with any real world traction. No physiological, demographic, economic or political references allowed; lots of mentions of 'today's society', but nothing sociological. It's completely, head-bangingly content free. (There's a Southern trans woman interviewed in one

filmette, who's achieved her authenticity through changing sex, but this is a glorious exception.)

To an English middle-class eye it looks completely idiotic. (It'd look pretty idiotic to an English working-class eye too.) But there's a logic to it; it's about knowing your audience. This kind of low-end life coaching simply can't afford to be too focused, so all that generality – that 'hi folks' implied commonality – looks like the safest approach. Don't mystify or exclude, just keep to the human condition. And, of course, there's a religious sub-text to all this. In the most religious country in the Western world, Americans can rely on audiences of other ordinary Americans feeling the faith in what they say – whether its ultimately about hitting marketing targets, getting laid or healing the hurt. This is why, quite irrespective of the audience concerns, the patter across an enormous range of these funny relationship entrepreneurs and micro-celebrities seems practically the same – word for word. Yet they always present it as an exclusive, a revelation.

The styles are riveting too. The men do conference informal and the women tend to do spiritual/elemental/

floaty. Some of the establishing stills are to die for. They're quite hilariously like Victorian pot-boiler pictures – astral perspectives, sunlit cornfields, views from the mountain top, literal leaps of faith from crag to crag. (I'm going to make a montage of these corny road-less-travelled images for my very own motivational talks. I guarantee every one will get a heartless laugh from my kind of audience.) And because Americans love academia, a fair few of those YouTubers advertise themselves as coming from 'universities' I've never heard of (and I'm not just doing another English thing here either – they sound really obscure and hamburgery).

Because this is an audience that knows faith – and some of the YouTube speakers do turn out to be explicitly religious – no one doubts for a moment that getting in touch with your authentic self really means getting in touch with your heart, your immortal soul, your kryptonite God particle. So it can't go wrong. Any secular questions about the nature of the self, about its malleability under pressure and over time, are simply irrelevant here. The authenticity pushers are convinced

of the infinite uniqueness of personality, the amazing fact that whoever you are, you're your own special person.

But the market researcher in me knows, from experience, that most people can be successfully identified, typologised and profitably herded, whatever some might say. Lots of people are astonishingly alike. The mythology of individualism – the idea of that fascinating difference – is the greatest commercial flattery of all. But if people weren't terribly similar and predictable, nothing – utilities, transport, department stores – would ever work.

There's a breed of life coach for everything now. One kind tells people – mainly women, but increasingly men too – how to present themselves in clothes and grooming terms for testing situations. This means mainly careerist stuff: at work and in work-related entertainment; company and colleague parties; sponsored sports; places with people who matter.

Earlier etiquette books' advice about dress was simpler; they worked on the premise that there was always a dress code for every occasion that was worth citing,

and it would never change. They set out what it was, then sounded awful warnings of the 'Never brown in town' kind (for men's shoes). Then they added a few exceptions and tweaks ('Blue may be worn in the second week of August').

But the new 'dress for success' guru types like to go far deeper, because they think they're advising about dynamic, fluid situations. They talk about the more human side of things, times where just knowing the form wouldn't be enough. They're concerned with relationships and personal branding, with making connections and winning people over. Getting on; changing your life.

Increasingly these books give men the same advice as PR stylists give politicians: let your humanity and your authenticity shine out; dress down; avoid formality (the over-dressed old economy look, the shiny chancer look). Instead, do what enterprising new economy people do and ham up your approachability; Richard Branson did this with his tactile Fair Isles. Which means ditch the tie when it isn't absolutely required. It's part of a new-ish orthodoxy that equates authenticity with

informality, in dress, in speech and in entertaining (especially the presentation of food). It's the thinking behind Tony Blair's famous glottal stops on daytime television with Des O'Connor. I'm not saying fashion and comfort don't matter, but this is stylist-chosen, agonised-over, calculated informality.

The same goes for speech codes too. Modest mockney-ism is the equivalent of dressing down; it's being real with people, so the feeling goes, because it's derived from more real kinds of people. There's drabbing of the accent for a bit of non-specific estuarine (you get it all over the country now) and doing little bits of business to make things sound that bit more free-form – small hesitations, deliberate forgivable grammar lapses. We all laugh at friends' children from Notting Hill doing their hilarious idea of mean streets' black slang. But it goes much wider than that. Being too conventionally correct, talking like an Oxford-Union-straight-to-think-tank policy wonk – or Jacob Rees-Mogg, at the extreme – sounds out of time and inauthentic now. There's even a business in coaching upper-middles from sheltered backgrounds to sound more 'with the people', to lose

the blah in their voices (this must be true; I read about it in *The Times*).[18]

Modern businesses in the winner-takes-all, high-growth segments like new tech and the creative industries have all had conspicuously informal dress codes from the off. If I worked at Facebook they'd refer me for therapy (Mark Zuckerberg, worth £32 billion, is famous for his daytime pyjamas). Every Silicon Roundabout jock from the Rich List wears the Steve Jobs 'T-shirt and trainers' uniform.

All this calculated informality, this getting down and getting real, is wildly inauthentic. It says we're all the same, while being absolutely comfortable about huge growing disparities in wealth and life chances. It's taken on board the styles and slogans of a mass of post-war liberations and welded them to the most iron-clad capitalism possible. Challenge Facebook or Virgin, or any of their easy-talking, dressed-down peer companies, on something substantive and you get some

18 'Voice coaches in demand to rub polish off posh accents', Ruth Gledhill, 7 April 2014.

very formal legal action. And, as we know from the Accounts Committee,[19] many of those delicious, informal, dressed-down companies are the ones which have the most elaborate formal mechanisms, produced by very tie-wearing and precisely spoken accountants and lawyers, to enable them to pay very little tax in the UK – or practically anywhere else. Behind much of the mighty realness of the new economy is a three-card trick.

Snakes in Suits[20] is a hugely entertaining American business book which argues that high-performing men – it is overwhelmingly men – at the top of American corporate life show an alarmingly high incidence of psychopathy. I'd just say it's snakes in trainers and T-shirts now. Snakes who talk in a therapy-speak inflected way; snakes who come on the conference platform and take their jackets off; snakes who do confessionals; snakes who do high-fiving audience walkabouts (like mosh-pit rock stars). Even David Cameron did the open-neck gambit for his job-winning speeches. The

19 The Public Accounts Committee, chaired by Margaret Hodge.

20 By Robert D. Hare, Harper Business (2006).

stylistic change in corporate life, much of it dreamed up by outside advisors in the creative industries, can be seen in the emerging orthodoxy of the active 'no ties'-rule event. If there's anything worse than the ancient hierarchical dress codes and sumptuary laws, it's their opposite: compulsory corporate informalism.

People assume politicians have all been trained up to high heaven, and many of them have – but usually only in rather basic media stuff. They've been told how to avoid gaffes, how not to answer the direct question, how to avoid a points defeat with a tough interviewer, and how to deliver the scripted message whatever is asked. But only a small group of very senior – or rich – politicians get a bespoke makeover, a stylist, hair and make-up, and a full-on personal branding overhaul, designed to make the pol' more engaging, empathetic and altogether more authentic. Like the best wigs, those are the jobs you don't know about.

American politicians are alarmingly – embarrassingly to British ears – likely to have authenticity claimed for them. Some, like Michele Bachmann or Sarah Palin, even claim it for themselves. They don't seem

to understand that the assertion gives lie to the whole enterprise. It reveals a world of analyses and calculations, of slaving over polls and replaying vox pops, of comms professionals, young men and women with Westminster rehearsal studios telling you what to do.

When Sajid Javid, the Tory MP for Bromsgrove, became Culture, Media and Sport Secretary in April 2014, there was quite a bit of rumbling in arts-land about his lack of Asian authenticity (his family background is Pakistani Muslim), because he was so sleek and suited. Where were the ethnic grace notes, the facial hair, the ancient wisdom? Javid talks numbers, but he couldn't be truthier. He was born in Rochdale, raised in Bristol and, as an out-performing meritocrat, went from his Bristol comprehensive to the rather sloaney Exeter University and thence to international banking – New York, Singapore, London – earning, they say, £3 million a year at the end. And he's pretty secular as well. So his super-smart suits and the rest are his reality. Any stylistic nod to the ethnic would be utterly fraudulent. (What do they expect? *My Son the Fanatic*?)

John Prescott (two Jags and a McMansion), by

contrast, absolutely lived off his back-story as ship's steward – 'another G&T, Giovanni,' is what the unstoppable Nicholas Soames apparently said.

But nowhere did the back-story matter as much as in popular music and its golden age.

Blind lemon shandy: authenticity in popular music

An American friend of mine in London often used to complain to me that nice English people were forever giving her what she called the 'blind lemon shandy' rap back in the '70s. They'd start by asking her views on ancient American bluesmen with those sorts of names – Blind Bill or Mississippi Mud Bob – who'd have been old even to her parents, but were tremendously, gratuitously authentic-sounding. She'd tell them that she was into Balenciaga and Barry White.

She's black, of course, and from the South, so nice English people thought they'd score brownie points by talking about the most authentic, liberally endorsed and bourgeoisly bohemian kind of black music imaginable.

The kind you couldn't dance to, and which young black people weren't interested in. Much of the presentation of old bluesmen to white audiences between the wars, it turns out, was hammed up to fit their expectations. Lead Belly went on stage in prison clothes and sang nothing but blues at manager John Lomax's insistence. He actually wanted to wear a smart suit and play hotel jazz.[21]

My own musical tastes – and I'd been lost in music, caught in a trap, for a fair bit of my younger life – were always ineffably inauthentic. It came naturally to me. I liked the things my bourgeois friends condemned as 'plastic' or, worse, 'commercial crossover' (when the performers were black). I liked Pure Pop for Now People; they liked virtuosity, artisticality and interesting back-stories. They liked things with a big idea; I liked things with a big noise. They liked acoustic, acapella, anything ostentatiously real; I liked Phil Spector's big studio-produced Wall of Sound (or his British imitator

21 *Faking It: The Quest for Authenticity in Popular Music* by Hugh Barker & Yuval Taylor, Faber, 2007.

Andrew Loog Oldham's version).[22] They liked their heroes to be 'intelligent' (code for 'middle-class like us'); I wanted mine to look good.

In the '60s Britpop mark one period, things were hard for pretentious bourgeois teens at first. It wasn't a precisely segmented market, more a case of be there or be square. There weren't many opportunities to demonstrate discerning superior taste that played to their strengths, but by the end of the decade and well on into the '70s the world went their way: the gentrifying upgrade from pop to rock. By then there was a raft of sensitive singer-songwriters, giants of prog rock, long-haired guitar heroes and every kind of fiercely authentic musical product, designed for students (and student manqués).

What really characterised the period was the increase in real incomes that had been stoking up, the first big leap in home ownership, and, above all, the vastly increased uptake of higher education, with more new

22 Andrew Loog Oldham was manager and producer of the Rolling Stones from 1963 to 1967 and responsible for their early highly produced pop sound, which drew heavily on the Phil Spector approach.

'plate-glass' universities coming online. Add in all the wannabes and you have a hugely growing market in positional goods among socially mobile young people (see Part III for more about my hideous kind of marketing speak).

Positional goods are things you can buy to express yourself with, which pretty much had meant clothes, music, liquor, cigarettes and drugs for most young Brits before new tech, easy credit, cheap long-haul travel, early home ownership, foodie-ism, body modification, identity politics and the rest. Young consumer capitalism circa 1970 looks positively primeval now. Music was massively defining for early '70s youth. But the middle-class twenty-somethings had gone way beyond the joy of the perfect three-minute single where you really had to respond viscerally. They preferred something altogether bigger, that played to their strengths and warranted their attention – a concept album; the real thing.

With concept albums, big, clever back-stories, and artistes who talked up a storm, we're into the world of *The Old Grey Whistle Test*, of those collections of

boys from places like Charterhouse (Genesis, with their token prole Phil Collins, for example) – absolutely everything I loathed. I'd open the *New Musical Express* – then a great power in the land – and find the lead article was about a Professor Longhair person who dressed so hideously and who talked such tosh that I'd bang it shut again.

The one sustaining thing for me then was black pop/ funk proto-disco: Sly and the Family Stone; Issac Hayes (the model for Mr T); or the occasional perfect pop single. And then the dam broke and there was glam. I loved it. Most of it obviously wasn't meant for me but for working-class early teens who'd felt increasingly shut out by the clever student stuff. It was highly visual in a panto way and designed for *Top of the Pops*. 'Hod-carriers in silver lycra,' was what inspired snobs said about groups like Slade and Sweet and the Glitter Band. All completely brilliant, I thought, rather like the synthpop marvels of the early '80s (buy the *Electric Dreams* compilation – it'll do your whole *Desert Island Discs* job in one go).

But by then – I feel compelled to tell you – I was

completely proficient in easy irony, and unusually lit-
erate in kitsch; I knew the so-bad-it's-good canon from
end to end. I'd read Susan Sontag's 'Notes on "Camp"'
and I could do 'Andy speak'[23] before I'd ever been to
the Factory and met him. And yet, and yet, I'd main-
tain that my unsuitable love of glam came absolutely
from the heart. Besides which, glam had its own big
idea, bourgeois outriders, its serious artists, its concept
album makers. It had David and Bryan, a pair of people
so fantastic they seemed like visitors from the twenty-
first century to broken Britain, 1973. So exactly what
you wanted if you were 'London art school' rather than
'northern redbrick'.

David Bowie and Bryan Ferry were people from
arts-land and fashion-land, people from the post-mod-
ernist's cookbook. They both looked wonderful and
were at the centre of clusters of what we'd call vis-
ual creatives now. They worked at it, so they were a

23 'Andy speak' is the affectless faux-naif style of interview response perfected
 by Andy Warhol and followed by the Factory. Bob Colacello, then editor
 of *Interview*, said to me in 1976: 'Oh, we don't have a philosophy at *Inter-
 view*, we just believe in money and beauty.' (He said it, 'Budey'.)

natural focus for the authenticity lobby's hatred. In 1974, there was Charles Shaar Murray,[24] then a great pillar of the *NME*'s rebel faculty – he was only twenty-three at the time – telling us precisely the threat Roxy Music represented to our ancient British rock musical culture what with their posey eclecticism, their poncey retrofuturism and their wholly meretricious concern with appearances.

Shaar Murray said that all Roxy's cultural borrowings, all the packaging, would mean there'd be absolutely nothing authentically '70s by which to remember them in ten years. They were a very bad example to all the other boys in the form; it could even be the end of the line. I wish the business model of this little book allowed me to show you a photograph of CSM circa 1973 alongside one of Bryan Ferry. It'd tell you everything.

But it was the classic rock authenticity argument

24 Charles Shaar Murray is an English writer and rock critic. He is the biographer of John Lee Hooker. As an *NME* columnist in the early '70s he was a power in the land. The look he favoured in that period was a street-fighting man afro and fuzzy sideburns.

Shaar Murray was peddling there. Artifice, historic reference and wit, a concern for art direction, fancy clothes and putting on a show were all signs of inauthenticity for Shaar Murray. Viewed from 2014, Roxy Music – like them or not – are generally acknowledged as hugely original and influential. Their obsession with art direction shaped the way the '80s generation of British pop stars presented themselves. We all sort of know that Bryan Ferry came from a very ordinary kind of near-Newcastle background. What I didn't know – until Roxy's biographer, Michael Bracewell, told me recently – was how much of Roxy's British fan base was always northern and working class:

> Roxy's appeal in the big northern cities in the depressed
> 1970s – beyond the intoxicating drama of the music – was
> the way they proposed street style as its own aristocracy/
> high life fantasy; that being a Roxy fan was to proclaim
> yourself, sartorially, as part of an elite, obsessed with
> image and exclusivity, and on-message to a received idea
> of a hyper-romantic stylised world, of which you were a
> kind of agent or ambassador. So all those clubs like Pip's

in Manchester or Gatsby's in Liverpool, became little
embassies for essentially working-class young people
to role-play their own aristocracy of style and cool.[25]

Just three years after Roxy's key emergent year (1973), we
got punk – British punk (which was always different from
the American kind, sweet, bourgeois, Lower Manhattan
art rockers with no national US influence at all). Because
of punk's creation myth – that it was all about alienated,
working-class youths breaking through – the authenticity
debate arrived immediately after with the most literal-
minded Jacobin interrogation. Every punk band had to
face a new line of questioning. How genuinely working
class were they? How much higher education had they
had? (By then, deeply suspect.) Were there recent pho-
tographs that showed them with tumbling hippie curls?
Where did they stand politically? How did they relate
to the big corporate record companies? (Engaging little
outfits like Rough Trade were fine.) This was a whole
new checklist to worry about.

25 *Re-make/Re-model: Becoming Roxy Music*, Faber, 2007.

The Sex Pistols, whose original strategy had been planned with a heavy dose of art-school situationist thinking by Malcolm McLaren, were both wildly authentic and deeply fake at the same time. They came, after all, pre-assembled, Svengali-ed from a Chelsea fashion shop. The Pistols themselves were – like thousands of groups before them, when nobody was that bothered – working-class enough to be going along with, and not a graduate among them. But they were brilliantly art-directed in a sort of anarchist panto – a bit like Eminem – in the first instance.

The Clash, who were more conventionally 'left', with a more predictable range of sympathies, soon registered as what we'd call activist Ladbroke Grove hipsters, based in the charming, improving, multiculti area where David Cameron lived more recently – the Shoreditch of '76. Their lead singer, Joe Strummer, was undeniably middle-class (it didn't matter at quite what level): he'd been privately educated and his father was some sort of diplomat. Two other members were art school (there'd even been a punk mantra of 'I never went to no art school', because the movement was obsessed with all these entrist students).

Of course punk was chock-full of comfortable bour-
geois people. It was terribly smart and London-y at the
beginning, but you couldn't say so. When I first set out to
meet the key figures, in 1976, it only look a few calls
to my very bourgeois homies – friends of *Harper's &
Queen*, the magazine I'd just started writing for. Mal-
colm McLaren and Vivienne Westwood I knew a little
already; I'd lived around the corner from Let It Rock,
the predecessor of their seminal shop Sex on the King's
Road, at World's End.

None of these contradictions made punk any the
less obsessively exciting for me, but it was a warning
to see the Jacobite stance developing. One of the many
things that did eventually kill punk off was the way left-
ist groups tried to work it to political advantage without
remotely understanding how it operated, least of all its
aesthetic. How high minds wrestled with the Clash's
'Like trousers, like brain' comment on their Jackson
Pollock paint-splash drainpipes (did they know how
American expressionists like Jackson Pollock had been
promoted by the CIA as an antidote to Soviet realism?).

All this showed was that literal-minded measures of

punk prole authenticity had nothing to say about the music or the spectacle. They were bound to fail practically everyone and end up just like that Python sketch about competitive misery and being brought up in cardboard boxes. But the paranoia it sparked went on and on. A few years later, when the apolitical Police were huge in New Wave, it was widely believed by the punk-chattering class that the band was a CIA plant since its manager's father, Miles Copeland Senior, worked in the Agency (he helped engineer the coup in Iran that bought the Shah to power!).

Hardcore British punk was hugely influential and a massive window of opportunity for all sorts of clever people. That's why I liked it – for the people it threw up, and the situations. But it was never popular music and never had much in the way of mainstream working-class sales. It didn't sell to the kids on the sink estates that featured in the imagery. It certainly wasn't a barrel of laughs and it didn't make you feel like dancing. Punk's heartland market was small and Questy, students who didn't identify with the old beery rockist mainstream. People like little Steven Morrissey in his Manchester bedroom.

But disco was huge and genuinely popular at the same time. Disco was dance music created at mixing desks, and fronted by unknown artists who didn't play anything (and, in cases like Milli Vanilli, didn't even sing). Disco took the manufactured group idea – The Monkees then; One Direction today – to a dizzy extreme. It practically stopped the public intellectuals of the music press in their tracks. Analyse this. Disco was quite marvellously inauthentic, and had great song lines like 'Born, born, born, to be alive!' so of course I loved it.[26] The artists' back-stories didn't matter, or their politics. What mattered, so the paranoids believed, was an Huxleyan formula of beats per minute, which acted to divert proletarian brains from social action. Now we know – *any fule kno* – that the Giorgio Moroder/ Donna Summer combinations were brilliant and anything from Chic was genius.

But disco was authentic in the sense of being hugely popular and pulling together a positive rainbow coalition of minorities. A lot of the artists were black and

26 'Born to Be Alive', Patrick Hernandez, 1979.

loved the music and the *Saturday Night Fever* scene itself. A sort of disco had been core to the gay bar formula forever – somewhere private. Gays like to dance and so do women. London's first 'ultra-disco' on the Studio 54 pattern, the Embassy in Bond Street, had been a curious alliance of gays, fashionable, louche, smart Londoners and attractive women who didn't want to be hassled. The 'Disco Sucks!' movement, made up of beefy American stadium rock fans who attacked disco for its inauthenticity, had a distinct undertow of racism, misogyny and homophobia.

But the most compelling phase of musical authenticity mania was still to come. Hip-hop had an advantage in that its pioneers were black people from the ghettos. But what they had to do to appeal powerfully to an audience of picket-fence, white suburbanites was be gangsterish. And dead. There is, of course, a roll-call of shot-and-killed hip-hop artists circulating. You can't beat that.

Part II

The last big thing;
the next big thing

CAN YOU SPEAK marketing? How fluently? I grew up on marketing speak. I was weirdly fascinated by advertising from a very early age – particularly American advertising, because the *Mad Men* stuff was miles more fun than our genteel kind when I was young. All of this was long before I'd ever been to America, and in an age before YouTube. What we did have, however, in London – and London always was different – were excitingly titled books about American advertising, and American magazines bought by expensive subscription. A neighbour got the *Saturday Evening Post*; we sometimes saw *Time* and

Newsweek; and there was always *National Geographic* with its yellow cover.

My best friend Mike's parents were ad-people, joined at the hip to New York. They had lots of American magazines with exuberant, colourful, exciting advertising. (We sometimes got diluted, made-for-Brits versions of global campaigns on ITV.) Every so often on the BBC, someone would show an American TV commercial as a cautionary tale about unregulated capitalist terribleness; I'd be on the edge of my seat with excitement.

Anyway, in my teens I'd read a fair few of these attractively titled books – especially Vance Packard's *The Hidden Persuaders* and its stablemates, Martin Mayer's *Madison Avenue USA*, and anything else that possibly came my way. They were already old-fashioned by then, but I didn't know (and, of course, I've got all those giant books of old press ads).

Everyone I knew – except Mike's parents – seemed to agree that advertising was dangerously dishonest and manipulative and designed to make simpler people than us buy things they didn't need. (This was '60s

north London!) In my obviously pathological inau-
thenticity, I completely tuned all that out. Just look
at it, I thought, it's insanely exciting. I'd like to work
there in J. Walter Thompson (JWT), Berkeley Square,
like Mike's parents.

So, for a variety of reasons, I was sort of literate
in marketing speak – the official argot of marketing
and advertising – very early on. And though I never
did work in an advertising agency, my first and only
employer's writing paper bore the legend 'marketing
and social research'. We saw a lot of British ad-men,
as sometime clients and collaborators. I loved them.

By my early twenties I could do quite a turn with
my lovely marketing speak vocabulary ('target market',
'user image', 'psychographics'). It was easy to get a rise
out of nice people with it then. Friends who'd gone
for nobler work – thoughtful thesping or radical bar-
ristering – asked me to speak plain English and said all
that sneakiness insulted people's intelligence. I'd say,
'If you become a star at the bar then you'll need a PR.'
That was way too much.

It was too much for British politics too, until Margaret

Thatcher formed her extraordinary alliance with Saatchi & Saatchi. After that, everyone wanted their own US-style presentation team.

The entire bien pensant world had long agreed that marketing was all about deceit, distortion, manipulation, pup-selling and glaring inauthenticity that was obvious to PLUs. And I was just in denial. Or just greedy. Or, later, just perverse/ironic. But what I loved about the darling old chancers in the '80s big British ad-land – the long-Chelsea-lunching, keep-the-cab-waiting types who were the glamorous end of marketing then – was their absolute lack of redemptive piety. You could see the fun they had, the big Glebe Place houses. And they talked like old actors – 'it's all illusion, darling.'

Advertising and marketing were always publicly vocal in their own defence. They keep the wheels of industry turning, employ creative types, create economies of scale and give you some fun. They brighten up your screens. They laughed to scorn the idea that they had excessive influence over ordinary, sensible, salt-of-the-earth Brits. But that wasn't what they said to their clients, of course. As a veteran of a thousand pitches, I've seen ad-men

parade their creativity and high science (hyper-segmentation, semiotic analysis, media selection) as completely irresistible, and I've seen marketing directors play all this back to their boards as if they were sending the Luftwaffe off in the Blitz.

A huge change came later in the '80s. The friends who'd mocked or loathed the eager-beaverness of my ghastly new vocabulary started to take it up themselves – tentatively at first, then more eagerly through the late '80s and into the early '90s. (New Labour, a project I saw as an insider-outsider, was the outcome of all that. Why should the devil have all the best tunes?) So I found arts-land friends I'd always, patronisingly, thought of as a bit unworldly, coming to me with ideas for my clients to sponsor their art openings, talking about upping the brand perceptions and connections. By 1997, the whole nation seemed to be ragingly complicit in financial services and marketing. All the fun of the fake.

But, fast-forward, did you know that the hot topic, the hot word in marketing speak land and its related territories of business boostering, this year is – and you're

there ahead of me – *authenticity*. There are big books on it, telling brand-owners to abjure wickedness and fakery and become authentic in everything they do. YouTube people who aren't on about psychic healing often turn out to be rather modest marketeers from Montana – a world away from the old darlings in Glebe Place, but still in roughly the same racket. And – would you credit it? – they're saying authenticity is the next big thing because research shows it's what people want. They're fed up with fakery and they can spot it a mile off. And even if they don't, someone online will tell them. Consumers are generally credited with being well informed now – 'savvy' is the usual word.

So, 21st-century marketing just has to be authentic. But, not only that, they're saying that the authenticity pitch really, really works. What they mean, of course, is the perception of authenticity. Those business books written by the same pairs of heavily credentialised and middle-initialled writers who always write this kind of thing in America (ideally they combine one WASPy-sounding name with either a Jewish- or Indian-sounding partner, covering all bases), work to a format. Just like

self-help books, they start with an engaging anecdote that characterises the problem.[27]

These books send an awful warning and give a call to action. You have flashbacks to the golden age in which the authors were raised: the myth of infinite prosperity and of the increasingly aspirant consumer, absolutely gagging for it forevermore. But now it's all changed, they tell us, and businesses that don't recognise it will go under. 'It's the eleventh hour, do it now, sign up to our twelve-point plan.' Here's how to be authentic. Authenticity, in other words, is to be the 21st-century saviour for marketing. So here are some hot marketing tips from *Authenticity: What Consumers Really Want*, by the gloriously named James H. Gilmore and B. Joseph Pine II, which proposes an authentic future for marketing.[28]

Authentic marketing sounds like the dictionary example for oxymoron, but James H. and B. Joseph

27 In the self-help books they so closely resemble, it's usually: 'Reader, that sinner was me'; while in popular business books it's instructive: 'So, where was that marketing director getting it so wrong?'

28 James H. Gilmore and B. Joseph Pine founded Strategic Horizons LLP in 1996 as a 'thinking studio' for businesses. They have a great track record for big ideas business books with natty titles like *The Experience Economy*.

are completely fearless. They have form among big issue business book writers: their *The Experience Economy*[29] was an influential bestseller. Their authenticity book comes from Harvard Business Review Press – the heartland of the American business establishment – and it was garlanded as one of *Time* magazine's '10 Ideas That Are Changing The World'.[30] So they're big and mainstream. I have to say with the best will in the world – and I wish I'd come up with as many world-beater book ideas as Jim and Joe – the authenticity tips that follow do strike one as more than a bit manipulative.

Their big idea was that 'consumers crave what's authentic … if customers don't view your offering as real, you'll be branded inauthentic – fake! – and risk losing sales'. So they tell the worried entrepreneur what to do. You've got to cook up some authenticity right now.

29 *The Experience Economy* (1998) proposed that consumers had moved to the top of Maslow's *Hierarchy* and beyond. They wanted *experiences* now, and providers of them would prosper.

30 *Time* magazine, 13 March 2008: http://content.time.com/time/specials/2007/article/0,28804,1720049_1720050_1722070,00.htm

The authors commend Starbucks, for instance, for their lovely earthy tones in their decoration and their delicious coffee vocabulary harnessing 'equatorial sunlight and the rainforest' to deliver you 'an exotic cup of coffee'.

It's fascinating to see what they recommend. They're very keen on design, for instance, and they love natural elements. 'Get some in,' they strongly recommend, 'Get images of earth, air, fire and water.' They love Anthropologie, the new generation department multiple store that uses a lot of re-thought salvage and upcycled stuff in its clothes and interiors. They love the Sand Hills Golf Course in Nebraska too – 'one of the most buzzworthy courses in the country'. They commend the holes 'spread so naturally through the remote landscape in Nebraska that it seems more of a discovered place than a constructed one'. And did you know about PRPS and their jeans?[31] Their website says 'authenticity is our first priority'. Flaws in denim is their specialism. They produce nothing but imperfect pairs. Jeans buyers at a certain

31 PRPS is a 'fresh denim' jeanswear brand that has been at the forefront of texturising and distressing.

level are more concerned with 'the quality of the flaw' than the actual material. Then, the Bare Minerals make-up brand is commended for offering 'the look and feel of beautiful bare skin', which sounds a bit oxymoronic.

Among the other authenticity strategies James Gilmore and Joe Pine II cover is celebrating company history (e.g. 'founded in 1952') and associations – reminding people of the long, cultural, iconic roles your brands have played in people's lives. They endorse Ian Schrager and his very original hotels and the Las Vegas Venetian Hotel for the way it references the real. All this is delivered without over-much ironic signalling. So for marketeers 'authentic' means new design ideas and a new vocabulary. It's all perfectly valid product development but it doesn't sound like the long-term answer to all the anti-fake resentments they've spent the previous chapters describing. But, like the Erhard[32] sensitivity training of the '70s – which seemed to de-sensitise people to failure or criticism – and like those dolls with a weighted rounded base that pop up

32 See the ageless Werner Erhard on YouTube.

cheerfully whatever you do to them – American mar-
keteers are perpetually resourceful and cheerful. There's
always an answer.

All these apparent sudden changes of heart, these urg-
ings to authenticity, provoke a huge range of 'what if's
– rather like authenticity's natural companions 'trans-
parency' and 'passion' too. If authenticity is translated in
a literal-minded way as being scrupulously honest with
potential consumers, going beyond the legal require-
ments of labelling on, say, food, then couldn't that be a
bit … counter-productive? What if product packs were
downright confessional and simply said:

> We don't want you to believe that this is any better than
> the main competition because it's basically the same stuff
> with all the active ingredients that really matter pro-
> cured from the same suppliers. To be honest you'd be
> better off with the Aldi budget version, which is better
> than either of ours.

> Love you lots,
> An Authentic Marketeer

They can't mean that, can they?

We all know that the food industry lobbyists have been paid millions to get to Whitehall to delay and dilute precise food-labelling legislation. (My fantasy is of talking computer chips in sweetie and crisp packaging that scream 'Type 2 diabetes and chafing thighs followed by amputation if you even touch me' at waddling blobs.) And we know that tobacco lobbyists have fought the threat of plain packaging for cigarettes everywhere in the world – they're actually trialling it in Australia now[33] – so it can't exactly mean owning up to everything.

Authenticity in marketing isn't quite the same as openness, which, literally translated, means your business should put it all out there. What everyone's paid in your organisation; what board-level expenses really cover; what your creative accountancy really does; what's off the balance sheet; what you're doing in the Cayman Islands. And the rest. But that can't be quite right either. (As a '90s PR tycoon once told me: 'Tell the truth; tell it like this.')

33 Lynton Crosby, the Tory Party's Australian-born electoral strategy guru, helped the Australian tobacco industry fight this initiative.

What the new authenticity and transparency raps have in common is that they're bought into business from specialists, up to a point. In the eternally positive worldview of people like me who sell 'business services', they're an opportunity to turn a trick. Just as there are people around to tell you how to be authentic, how to manage it, so there are people – corporate and financial PRs – who'll do your transparency for you, tell you what to own up to as a trade-off against keeping the rest secret. It's like 'crisis management' when the plane's crashed or you've poisoned half of South America by accident. Same people, same techniques. Or, to take a slightly earlier business enthusiasm, Corporate Social Responsibility, which was such a time-consuming bore that you had to get those PR/lobbyist types in again to make you sound corporately responsible too – lovely initiatives with schools in Hackney; middle managers fun-running for charity. Enron, the biggest bankruptcy in America's history, was a brilliant corporate citizen.

In America, the authenticity rap comes from a long line of store-front religion. It's small-town, small business stuff. It's a tradition that was originally a world

away from big government and global corporations. But new technology has taken sharing onto another much bigger stage – social media and the urge to global reciprocal confidences. The drive to share, to be open, even 'vulnerable', is central to the authenticity story. 'Closed', 'defended' people, by implication, are inauthentic, they're not so much disciplined or stoical, they're repressed. And the idea of repression is central to the psychological crusade, to talking therapies and the ideas about personalities and how they're shaped.

The argument goes that what all authenticity shills describe as 'social pressures' cut people off from their true selves by constantly urging them to live up to inauthentic, impossible role models. Their 'alternative' view is of the elemental self, the soul, the source of authentic behaviour, consistent and unchanging. What this line doesn't allow for are the useful social pressures towards, say, probity, social responsibility or collective action. And it's at odds with practically any scientific view of the development of personality and the trade-off between nature and nurture, genetics and culture – family, milieu, education and experience. The idea of

the authentic self isn't genetic determinism, it's much nearer mysticism. It doesn't allow for people developing, feeling and believing radically different things in the course of their lives, being open to debate and change. Authentic 2014 says 'I did it my way', I found my truth and I stuck with it.

Mindfulness is big in thoughtful circles now. It's the 2014 re-badging of Buddhist meditation so popular with '80s entrepreneurs. It's apparently all about living in the moment, which is presumably what oysters and mussels do. But for me it's another way of never having to grow up.

Faux authenticity in the form of defiance and rebellion has been a constant theme of advertising and marketing at every level since well back into the '60s. The idea and the imagery of the anti-conformist young rebel making connections with his truth was stolen from '50s movies and early '60s Britpop to position brands at teenage consumers (and, later, at middle-aged ones).[34] So mass brands addressed huge audiences through mass media

34 Thomas Frank describes all this brilliantly in *The Conquest of Cool*, University of Chicago Press, 1997.

and told them to be just like that one defiant rebel out on his own.

When that single rebel became the mainstream, they did it all over again in 2014. They're still doing it, but more so and more cleverly, more post-modernly, more ironically. The invitation to defy convention and find your own truth has gone wider through marketing – way up the age groups and across a great range of sectors. The middle-aged, up-scale consumer was invited to reconnect with his urgent desires – the 'Stop dreaming, start riding' or 'Most things that feel this good have been outlawed' '90s advertising by Harley-Davidson was aimed at better-off baby boomers re-discovering their elemental drives and juices.

The anti-bourgeois 'Rebel Yell'[35] stance infected everything from furnishing ads for Ikea to car branding. Pioneering Audi advertising of the late '80s positioned the brand against bling Mercedes as authentic, inner-directed and played-down. A touch of rebellion – however it's cast and art-directed month-by-month –

35 Billy Idol, 'Rebel Yell' (1983).

has always served as a proxy for personal authenticity, in what seems like a particularly absurd bit of audience flattery. It's the kind of advertising approach people mock ostentatiously in research, and then, often enough, go on to show that they've remembered in some detail. It works commercially.

These heroic rebels of consumption were urged to demonstrate their singularity and authenticity with nothing more dangerous than the choice of a lager, a pair of jeans or a themed restaurant. And they had voices from the past to urge them on – risk-taking personal brands, from Steve McQueen to Miles Davies and Chet Baker – pressed into service through amazing digital tricks. Marketing has made personal authenticity look like an easy option, a low-threshold buying decision.

It's always easy in the come-up-to-the-front-and-be-saved world of fake authenticity, whether it's rebellious advertising, life coaches or business motivational speakers. They all go on about the crippling, repressive power of conformity – but look around, not a tie in the hall – and about the hard decisions to be taken, the vertiginous bungee jump that follows, all that. Then they

invite you to simply follow your heart. But what if your heart, your God particle, took you to *jihad* or serial killing, hardcore pornography production or paedophilia? Authenticity – finding yourself – doesn't, and can't, allow for the idea that a fair few authentic selves might be authentically appalling and so much better repressed. That's why the personal authenticity movement is so accessibly, inclusively vague about specifics, except for the kind of personal 'journeys' that provoke applause on daytime TV. Or getting that Harley.

The sheer ubiquity of clever faking-it, the marketing of clichéd-looking routes to authenticity, has pushed ambitious types in new places to try even harder to establish their authenticity through originality and stylistic pioneering. They want more certified sources, more ironic references and more clever ways to be special than the smart middle-class 'early adopters' they're playing off against. In life's Shoreditches – there are micro-Shoreditches in Manchester, Glasgow and Sheffield now, full of bare-brick bar restaurants and waiters in peak beard – it's long been an article of faith to re-work old, working-class, retro, council-flat furnishing

and dress codes. In the '90s, that meant a Tretchikoff[36] *Green Lady* and splay-legged furniture – retro proles with their synthetic stripey polo-shirts seemed extravagantly authentic to art-school kids raised on punk. Now that cohort is pushing fifty, their successors have got altogether more desperate. Chris Morris's *Nathan Barley*[37] spoof seemed rather understated to people who know Shoreditch.

Everything that's really happening now is fake in the sense of being invented, thought-up, man-made, of being increasingly technologically based – our everyday lives are amazing, viewed just from the '80s – and ever-more commercially mediated. Money talks, from universities to healthcare. And most important social developments are pressuring people to be manically competitive, solipsistic and fraudulent, constructing boosterish CVs and personal brands – what a recent

36 Vladimir Tretchikoff (1913–2006): one of the most commercially successful artists of all time, his painting *Chinese Girl* (known as *The Green Lady*) is one of the bestselling art prints of the twentieth century.

37 *Nathan Barley*: a Channel 4 sitcom about the artsy end of London life (first broadcast in 2005).

BBC documentary called 'Generation Right'.[38] In education, the middle-class emphasis is on developing children to hardwire the advantage their parents have achieved. Forget their lovely authentic selves, we're going to get them into Oxford or Harvard, we're going to raise them as high-status champions. Tiger moms aren't just in Asia, they're all across the Western world. That's how it is, get over it.

But for every trend there's a counter-trend, a reaction, a bit of resistance. And for every bit of successful fraudulence, there's an increasing ability to get your eye in, to spot the lie. What looked inspirational a decade ago starts to look cheesy. There've been shocks *to* the system, a long, painful crisis which has left a lot of people who'd once thought they belonged in the rising-tide economy wondering if they'll ever make it back up there. And there've been shocks *about* the system, about the behaviour of money men, politicians and media people, all way down in the polls everywhere.

The idea of authenticity, of people levelling with you,

38 *Generation Right*, BBC Radio 4 documentary first transmitted in June 2014.

appeals precisely because people feel they've been lied to, particularly by lucky people utterly remote from their lives – insiders with money and education and networks, all in it together. People who obviously aren't real because they don't sound it, because what they say is evasive and self-serving and the way they say it – the curious language and accents of Westminster – doesn't connect (and this doesn't mean just Tory toffs like Cameron: Ed Miliband sounds every bit as metropolitan and fancy-talking and inauthentic if you're up against it in Rotherham).[39]

An astonishing level of contrivance is built into the way the world works now. There's the complete opacity of meta-finance in its combination of proprietary trading, dizzyingly high technology,[40] abstraction and globalisation – the scale and influence of global companies which, by definition, can't really act in ways that people see as authentic. Companies talk endlessly about

39 The town which the philosopher Julian Baggini identified as the demographic dead-centre of Britain for his *Welcome to Everytown*.

40 The world of Michael Lewis's *Flash Boys* and the building of a super cable that gave speculators a micro-second advantage from which they made billions.

devolving and empowerment (another authenticity fellow traveller), but increasingly seem to re-order the whole world to their own ends.

Huge global corporations employ specialists to create global brands, or plausible film-set shops in identical developments across the world. The extraordinary irony here is in the employment of designers – shot-full of big ideas at art school, natural micro-connoisseurs and authenticity chasers in their own lives – to think up the ever-more convincing fakery all around us.

Authenticity and micro-connoisseurs

I'm completely obsessed with the luxury goods trade – have been for years. It's built on a very special business model, that of creating and maintaining brands so magical they command enormously high prices, way over the top-of-the-range prices in familiar categories – the home-grown premium brands. And the big idea is that these super-normal prices, if you can continue to extract them, mean super-normal profits.

To maintain the magic, the big luxury goods

businesses spend enormous amounts on marketing and presentation, PR and advertising and perfect websites. Beautiful uptown flagship shops with beautiful assistants; parties for front-row people; beautiful wrapping paper and bags; and ruthless control of brand presentation everywhere.[41]

Most of the major luxury brands have a long backstory – a famous designer, an extraordinary workshop and a history of cast-iron clients, aristocratic, plutocratic and A-list stars. These histories are their claim to authenticity. They date from a time when the businesses were small, privately/family-owned and genuinely *artisanal*. But are those companies authentic now (however many fakes they destroy)? Almost every luxury brand of clothing and accessories you've heard of is owned either by a huge conglomerate like LVMH or by a private equity business. They are global businesses in upscale malls from Brussels to Beijing. Things are made differently and in different ranges for different markets. But

41 Big watch brands like Rolex are forever organising filmed public steamrollering of fakes.

here comes the really difficult bit, the light let in on magic: a lot of the production is contracted out in the Far East where they might just roll down the production line alongside a batch for Next or Primark. And there are loopholes in labelling that allow things substantially made somewhere cheaper to be labelled 'Made in Italy' – or England, France etc. – if you sew on a few buttons there.

All this means that the magic creation, the brand-making, needs to be turned up constantly. So are these businesses and their products authentic? Forget legally, but in the spirit of the thing? This is a rich-world question, but the rich world is now hugely bigger than it was, and the market for luxury, for superior, smart, snobby, value-added luxury goods – 'positional goods' of all kinds – is now enormous, becoming ever-more striving and jostling, and genuinely discriminating too. At this high point of global consumer capitalism we've got millions of micro-connoisseurs agonising about the thread count in sheets, the back-story of a recipe, the provenance of a shop.

As fast as new customers are recruited to the nursery

slopes of packaged luxe with visible branding (big logos) from new money Hanoi or Lagos, new knocked-back anti-bling shoppers are emerging from older markets. They're looking, looking, looking for the real things; they're after authentic experiences; they're learning the kind of micro-connoisseurship that allows them to pronounce on places, products and experiences. They want to be able say to whether they're authentic – that's the key to authority (same root to the words, of course).

The lovely idea of authenticity is central to this new micro-connoisseurship – in sheets and shirts, food, design, tweed, bespoke men's shoes, spa hotels in exotic places. It's the 21st-century equivalent of talking about wine labels and vintages, greatly expanded and democratised. There are sites for it. Americans are asking each other about British shoemakers and Italian cloth – Loro Piana or Brioni; Berluti or Crockett & Jones. Identifying the authentic – and telling someone else along the way that they've got it so wrong – delivers a very refined pleasure, tinged with schadenfreude, far beyond the innocent delight in a Vuitton bag or Versace jeans.

Micro-connoisseurship works at every possible level

– from artisan bakeries and ostentatiously independent coffee shops to paints made from eighteenth-century formulae and design art. There's now a specialist/'luxury' value-added version of practically every ordinary thing now, and most of them say they're authentic. After the British new rich got their minds around those American side-by-side fridges with ice makers as big as wardrobes in the '90s (and then later the merely comfortable started buying them too), the top-end market moved up to a new price-band. It moved to massive multi-function fridges from America (like Sub-Zero, starter price £12,000), while high design-land bought the German hyper-brand Gaggenau, and even John Lewis had a break-front branded monster – the central panel is a wine fridge – for about £6,000 (a friend is marrying a hedge fund man who has this thing). Where's the authentic functional alibi, the superior story, in a fridge? They'll find one.

In a time gone by, I ate at Dino's, near South Kensington station, at least once a week. Dino's cheap slop – over-cooked pasta with strong sauces and lots of pepper and parmi – suited me, just like a range of Greek places

called The Hellenic, or practically anywhere cheap in
Earls Court. I didn't know any better; it never occurred
to me to worry whether any of this was authentic. Strong
taste, quantity and low price were my criteria. I'd already
learnt that, disappointingly, Italian food in Italy didn't
taste quite like that. I preferred Dino's. I know that most
of those dishes were sort-of wrong now because I know
pro foodies and I've tuned into their talk. But then you're
in the hall of mirrors again, because some foodies have
gone ironic, they've had their campy retro moments,
they've redeemed '70s and '80s food, declared it legit
once it's safely period – so prawn cocktail, chicken Kiev
(or Pollo Sorpresa) and Black Forest Gateau for all, with
Lambrusco. Fizzy red wine – fantastic.

The authenticity of Kitsch is great doublethink.
Kitsch food – like kitsch anything else – has its own
claims now, and its own engaging proselytisers.

It's so period that almost everyone has safely moved
on. You can own it and re-present it. People will under-
stand how smart you've been.

It was once genuinely, incontrovertibly, wildly
popular – the food of real people before markets got

fragmented and segmented. And whatever the people did is authentic. So long as they're not 21st-century *Benefit Street* types. When fat-filled burgers are re-presented with authentic named-breed meat for the mince, they leap the species barrier.

So, in a number of self-conscious ways, elements of popular '70s and '80s food – things I really liked – have been re-played in smart, expensive places for the last fifteen years. Spooky. It's a counterpoint to authentic Smithfield nose-to-tail eating and strong peasanty flavours. So we get a menu like that of Shrimpy's, the hot King's Cross hit of 2012, set in an old petrol station near the new St Martin's. In Shrimpy's, magazine art directors could eat a soft-shell crab burger, seafood bucket or a banana & peanut butter sandwich. Was Shrimpy's authentic – true to something in its fashion – or just defying middle-brow ideas of authenticity with an art-school gesture?

London restaurant design is at a spectacular high point of pastiche in 2014. In the space of eleven years, Chris and Jeremy – Chris Corbin and Jeremy King – have opened five brilliantly executed European 'grand cafés'

with various themes and periods – nothing later than the '20s – in central London. The first, The Wolseley in Piccadilly (opened 2003), really was in a spectacular setting – a '20s car showroom perfectly restored by the late David Collins. The next three – The Delaunay in Aldwych, Colbert in Sloane Square, and Fischer's on Marylebone High Street – were reconstructed from scratch like film-sets. Even Zédel off Piccadilly, originally the huge spectacular deco basement of a '20s hotel, was completely re-thought and Frenchified – made even more spectacular and deco.

Like Roxy Music, these restaurants – hugely popular and practically the posh Lyons Corner Houses of our day – are brilliantly done, the pastiche is clever, the references are thought-through, the design detailing is good. We know, we absolutely know, that old Viennese cafés didn't have quite these menus, or diners who were public affairs directors, hedge funders, celebrity agents, or remotely like anyone in those new milieu. But we don't care. All the provenance comes from Chris and Jeremy's thirty-year history in London restaurants, being in the smart places at the right time, sensing the mood.

They've just opened a new hotel in Mayfair, The Beaumont (late 2014), and the theme is 'the pre-war elegance of Mayfair hotels … grand in style, yet intimate in feel', with Turkish baths too. It's another pastiche, and yet it's authentically them.

While we're on food, it's worth saying that authenticity judgements about restaurants and dishes work on a different level – more imprecise, more moralising, more posey – than the 'f' for fake and 'r' for real of the protected species of food and drink, the *appellation d'origine contrôlée* (controlled designation of origin). A single thing – a cheese from a place made to a formula, a wine from an estate – is either right or it's not (if you care). But it is menus and dishes that get people going – 'Authentic cassoulet would never contain X' or 'My mother would never have made Queen of Puddings with Y'.

After organic and rare breeds became commonplace commendations, the urge to 'localism' in food became torrential. Your food should have been produced no more than ten cart-minutes away, which would keep you staked to the restrictions of the seasons and the

area. I'm waiting for the medieval diet on Gwynnie's website (subscribe now!).

But things change and they always have. Every kind of food that's ever got from Lyons to Paris, let alone crossed the Channel, has changed along the way. Poor people's food used what was affordable and to hand, but give them some money and they'll use Kobe beef and double cream. Food, as Ann Barr and Paul Levy's brilliant *Foodies* showed, is, more and more in rich countries, the expression of how we feel about the world, about politics (organic, vegetarian, fairtrade), about aesthetics (blingy fine dining or nose-to-tail everything), and about our take on life-science orthodoxies (fat versus sugar, protein to veg ratios). Your choices show you're travelled, experienced, educated and deeply caring.

Were Berni Inns authentic – I'm looking at an old Berni Inn menu now, remembering how it was laughed out of town in the '90s and thinking how its steak-and-chips menu has been very successfully re-introduced – in a pastiche Frenchy setting? There's been a raft of more expensive uptown steak-and-frites joints in the last five

years, places like Gaucho, Relais de Venise L'Entrecôte and Bob Bob Ricard.

Authenticity in twentieth-century designer furniture – another strand of those YouTube films – is deliciously contradictory. The key designers, from the Bauhaus Heavy mob to the Eames, designed for volume, had an aesthetic and an ideology of mass-production. As Deyan Sudjic has pointed out,[42] they made prototypes by the old methods and changed them, but the real thing was the industrial production, where details changed over time and between licensed manufacturers. It's absolutely not a set of single library chairs from Thomas Chippendale with a written bill kept by the estate manager. But the talking-up of any identifiable authentic detail maintains the brands and the prices, in the face of very convincing fakes at about a third of the price.

Tom Wolfe pointed out in the '70s that heroic pieces of '20s and '30s furniture designed 'for the people', like the Mies van der Rohe Barcelona chair, had already been appropriated as smart accessories for Fifth Avenue

42 In *B is for Bauhaus*, Particular Books, 2014.

corporate headquarters and apartment blocks – a world away from worker housing – by the late '20s. They featured in the Museum of Modern Art (MOMA), founded in 1929 by as stellar a batch of capitalists as you could imagine then – Rockefeller, Mary Quinn Sullivan, Lillie P. Bliss and Anson Goodyear. Start as you mean to go on; the 'specials' from the output of those great architect designers – early versions with a back-story – now make tens of thousands in the mid-century modern sales at Phillips. A nice bit of '50s Conran is a collector's tipple too.

There's a great cautionary tale for snobs who rely on anciency as a proxy for authenticity – the marvellous world of old fakes, old conspiracies, old pastiches and lash-ups. *The Invention of Tradition* (1983) is a collection of essays by historians, put together by Eric Hobsbawm, which brilliantly take apart historic scams. Hugh Trevor-Roper showed how the bagpipes-and-tartan notion of Scottish history was largely invented in the nineteenth century by Walter Scott, along with an amazing pair of young chancers, the Allen Brothers, and a lobby of woollen mills and hoteliers – all to delight our German monarchs and drum up trade.

Much of British royal tradition – the kind of thing Linda Snell thinks has a thousand-year unbroken history – is more recent still. It's largely late-nineteenth-century and Edwardian, as David Cannadine showed. It was driven by the need to market the Empire abroad (the invention of the Delhi Durbars) and to use the monarchy as a focus for social cohesion at home. It's the creation of new technologies, mass-circulation newspapers and photographic reproduction and, later, radio. Old fakes and pastiches take on an authority after more than a hundred years if they've got royal associations and the right kind of endorsement.

There are a number of outed fakes and pastiches, inauthentic at the time, that are eagerly collected now. In the late-nineteenth/early twentieth century, furniture makers like Edwards & Roberts made beautiful reproductions of 'classic' eighteenth-century furniture. Then they overdid it – painted swags of inescapably Edwardian flowers all over things – and sold it to people who'd got the 'real' thing in their attics. Once despised by the post-war Country Lifers, this stuff is eagerly collected now. Or take Samson porcelain, a precise

nineteenth-century French imitation of Chinese famille rose porcelain. When you've got your 21st-century eye in, it doesn't really look Chinese, but if you're into nineteenth-century bling, which means huge houses full of new 1880 'Louis' furniture, then you can absolutely see the point of a nice, big Samson pot-pourri bowl. It'd look fine in a Robber Baron house.

The idea of authenticity can only exist in a constant tension with the idea of inauthenticity. In old world semantics that was easy enough. People and things that simply weren't what they said, were 'f' for fake – like Han van Meegeren's Vermeers, or Thomas Keating's Gainsboroughs.[43] But as the notion of authenticity becomes more vague, inflated and assertive, so the comparisons fade and defining inauthenticity becomes about as pointless as outing witches.

When 'f' for fake was a simpler matter, in modest places and with things never intended for auction houses, there

43 Han van Meegeren (1889–1947): produced famously believable Vermeers in the '30s and '40s; failed almost anything saleable. Thomas Keating (1917–84): British art forger; copied a great many famous artists but notably Rembrandt and Gainsborough.

was jolly cliché pastiche – Mark I 'Indian' and 'Italian' restaurants in provincial Britain that were obvious to a sophisticated eye (there was Chicken Tikka, a gloriously invented dish that everyone adored, especially with chips). At another level (art forgeries, legal documents, antiquities), some very sophisticated and convincing things were made (and some are still in important collections). The thing about those professional art fakes was that there was an obvious test to be applied (simple in principle, at least): is its alleged authorship and provenance true or not? Difficult in practice, of course, but with high science and better history, a number of old fakes have been identified and quietly de-acquisitioned. A fair few of those van Meegerens and Thomas Keatings have been found – and now there's a nice little market in them too – and there's every disincentive possible against outing the rest. Everyone in the supply chain – auction houses, galleries etc. – would look bad and could be sued, and people on the demand side – collectors and individuals – would suffer wealth destruction and, worse, ridicule.

The new kind of theme park fakery is altogether more difficult. At a physical level, it's often impressive. The

builders and designers of themed hotels and restaurants have done their homework: they've used people with an eye for detail; they've often re-worked old buildings rather than charmless new ones; they've used architectural salvage, and the new infill is assiduously distressed – stained and bashed and smoked by people who used to fake antiques. Set decoration – in feature films and high-end TV drama – has never been so good. People know movie lenses are sharper, screens are bigger and there's HD. It can't all be plaster and paint now – and the every-day tricks are astonishing. In a recent BBC drama about Dylan Thomas, a scene on the balcony of the Chelsea Hotel in New York (c.1953) showed an utterly con-vincing '50s streetscape of people and cars below which looked nothing like the old back-projection trick.

In the new bare-brick-walled developers' instant loft and studio world, we know – most of us, if we think about it – that it's a trick and a trope. But it's often charming because the developers and designers have tried harder to be more authentic, more fully realised, than the authentically naïve low-budget interiors they've replaced. It's flattering to the occupants. They've made

an effort and we like them for it. And younger rich people in their designer sweats and vintage trainers can look well above and beyond their money.

Confusingly, for a generation that grew up on easy post-modern irony and all those topsy-turvy land inversions of identity politics and modern-class postures like mockney, fake can be super real. For people like that – and there are lots of them about now – plastic, for instance, can be terribly authentic because it's what The People have, or used to. And some popular culture is more authentic than high culture because it's The People's stuff too and you can use it/re-work it any way you like. It's more participative if you do the trailer trash thing to the max like Dolly Parton (who knows how to play earnest middle-class boys when she talks about her background and says 'it costs a lot of money to look this cheap').

If you regress a group of people through the word authenticity and what it provokes in them (I'm the veteran of thousands of focus groups) you build up a picture of what an authentic person, place or object is supposed to be like:

It's from the heart – it's about raw emotion, not tedium, rationality and slog.

It's singular and individual, rather than collective and multiple.

It's probably long-established – it's got some anciency and some associations (a bit of provenance is a lingering trace from the old antique trade meaning), or, for people, a poignant back-story.

It's resonant (another favourite associative word) – it provokes empathy; it gets you right there.

It's rare/in a minority – the rare real thing or person in a world of fakes ('Is it me you're looking for?').

It's natural, made, grown or nurtured in proper (i.e. old-fashioned) ways from real things 'to a time-honoured recipe'.

By artisans – it's *artisanal*!

By extension, for some purists, it's organic – real food for them means organic. No Frankenstein interventions and no hurry; local food, slow cooking.

It's exotic or ethnic – for lots of bien pensant Westerners, we're all beyond hope, and only distant different people have the simplicity/spirituality needed for authenticity.[44]

A particular sub-set of this is the idea that black people are especially authentic.

For others, it's our very own noble savages. Authenticity is about the idea of working-class people who aren't bitter and twisted by bourgeois careerism and pretentiousness. They're real! They're direct! They know how to enjoy themselves! The exact working class that's evoked here is more difficult to define now – it's certainly not Owen Jones's demonised chavs or *TOWIE* types. The association is with a set of disappearing

44 This idea is ancient itself – it comes from the eighteenth-century 'noble savage' idea attributed to Rousseau.

stereotypes of public sector types like firemen and train drivers, rather than call-centre workers.

Authentic things are 'made with love' (a favourite of food industry copywriting) with a very small-scale, pre-industrial methodology. It's your neighbours' home-baked cake, not Mr Kipling's (Mr Kipling was an exceedingly good late-'60s copywriting invention with great dollops of personalisation and Edwardian associations – but it doesn't work in the farmers' market decade).

Vibrant semantics: authenticity and its little friends

Authenticity has a number of little friends, giveaway words that share some of its platforms and its fans. They're words with a formerly middling status in wordland, neither totally heart-stirring nor exactly wispy either, taken over by new inflationary big talk. Words like 'spontaneous', for instance. 'Spontaneous' is a reasonable adjective, with a fairly clear set of old meanings, that's been prised loose from its history. Spontaneity

is often taken, like informality, as a building block of authenticity. Spontaneous people whose minds and diaries could turn on a sixpence – people very much in touch with their inner child or their own adorable idiot savant – are often described as authentic. The comparison is always with planners – cautious, calculating and highly diarised types.

The idea of spontaneity is appealing in attractive young people and dogs, for a few hours, but in anyone else, for any longer, it's actually more than just maddening, it's borderline mad, as Steven Poole explained recently in the *New Statesman*: 'It hardly seems to matter that anyone who really acted according to this ideology would be a kind of sociopath.'[45]

Like authenticity, 'spontaneous' is annoying now, because it's been stolen to build a clichéd character type. As a friend said of a tiringly 'spontaneous', whimsical acquaintance of his, 'She's working so hard on her personality, she hasn't got time to do a job.'

45 Steven Poole, 'Think before you act: against the modern cult of spontaneity', *New Statesman*, 16 July 2014.

Another word in the same boat now is 'passionate'. 'Passionate' has already been extensively duffed-up by the broadsheet cliché police, and was lashed by the *BBC Management Magazine* because it's appeared in so many dreadful ads, commercial straplines and, worst of all, inflated CVs – places where it looks particularly lugubrious. 'Passionate' sank into uttermost bathos from its over-use by people gushing about their unlikely passions for everything from fish farming to hotel management. (Other CV words 'passionate' links to in turn include 'dynamic', 'creative' and 'motivated'.) People who took 'passionate' from the buzz-shelf obviously had no idea of its origins. The religious and artistic history was irrelevant, or, as with 'authentic', they just wouldn't have used it like that.

'Passionate' is more than a parallel with 'authentic'; they do gigs together. Passion is another key factor in the modern personality. 'Passionate' means, over-and-over for motivational speakers, 'following your heart' and feeling deeply. That's a metaphor that comes as close as Rizla to the authenticity creation myth of re-connecting with your true self. 'Passionate' has been outed before

'authentic' because of its dramatic over-statement. But we all know the authentic's time will come.

In other contexts – the description of areas and communities – authenticity shares the stage with 'vibrant', which has gone from the simple idea of vibration and the sound of music and voices, to something altogether more high-concept. 'Vibrancy' is now a key positive quality of urban life, a developer's PR word. It means a certain kind of cultural and commercial consumption, the delicious downtown involvement of the arts, particularly the more spontaneous performing and inclusive sorts of things. 'Vibrancy' suggests street life, hipsters, hanging out, eating out, vague ideas of community and strong implications of multiculturalism (even if it's only in the restaurant staff). Places vaunting their vibrancy always have shops and restaurants which describe what they sell as authentic. How delicious it is to see bankers down Brick Lane vibrating along with the local community in a spirit of total mutual incomprehension.

If you judge a word by the company it keeps, you see that authenticity – 21st-century authenticity – belongs in the world of arbitrary over-claims, solipsistic

assertations and mid-market commercial come-ons. It's one of a group of words that have been appropriated, as the sociologists say, to serve in new inflated roles. They've become desperately aspirational words meant to elevate everything they touch. They're so usefully woolly.

'Authentic' fits the 'me' generation tradition because now it's used overwhelmingly in the area of individual experience and the authenticity of emotion. It's about feelings, assertions and judgements. Truth and fairness – particularly to oneself – are marginally involved, but boring difficult facts aren't. Authenticity is an alternative kind of truth. The authenticity movement, being all heart, finds it difficult to take on board anything as crunchy as social, economic or even physiological context. Why are people unhappy? Because they haven't connected to their true selves, haven't made the leap that would empower them (another word-alert there) to reach their potential. Not because they're poor or ill or badly educated. Many of the ideas implicit in authenticity are profoundly backward-looking and deeply conservative 'anybody can do anything' stuff.

'Sincerity' is another glorious weapon-word you can use on a daily basis. As George Burns said, 'If you can fake sincerity, you've got it made.' It's a simpler idea than authenticity. It's about meaning what you say, what you emote, what your body language signals. It's about comms. Sincerity doesn't require any elaborate getting-in-touch-with-the-self, or any existentialist personal rebranding. When sincerity's fake, it's an old thespy intentional kind of faking, not a 'me' generation failure. Tony Blair specialised in a sort of blazing-eyed sincerity and, like The Bachelors, constantly said 'I believe'.

I'm not that fussed about good English, not a Fowlerist. I don't email Radio 4 crossly if someone ends a sentence with a preposition or uses the historic present. I'm not being a grammarian when I point out the semantic company authenticity 2014 keeps. I've simply been at pains to trash the people who use authenticity, without irony, all the time as a measure of their evolved personalities, their marketing prescience or their ability to help their buddies get laid. So, naturally, I've noticed the other words those people use. You can't go far in authenticity's company – the odd new dining

or shopping experience, a conference, an excitable marketing suite or a YouTube binge – without meeting other words that belong in the club.

Consider, for instance, the unutterably gorgeous idea of creativity, a sort of secular magic that can change lives, banish slums and poverty, and generally teach the world to sing. The creative industries, a clever bit of taxonomy and labelling by my friend John Sorrell, deliver all the business of human happiness in one go. (They certainly keep a lot of my friends employed.) And they're growing, while the un-creative industries have declined. They're very possibly, as everyone in Westminster has learnt to say, the saviours of the nation; America may have electronic entertainment, high tech and investment banking, but we have our creative industries.

The definition of creativity is elusive, but it's usually seen as coming from 'free spirits', original people who're in touch with their kryptonite, who are uninhibited and thoroughly out-of-the-box. Creatives are authentic. Whether everyone who works in the creative industries is miles more creative and authentic than any dumb schmuck who works in, say, plumbing supplies

manufacturing, is a difficult question, like the philo-
sophical riddle of cricketers and Frenchmen – but it
seems unfair.

You get the picture – the idea of authenticity is proxy
and provoker for a lot of other words and ideas, many
of them snobbish and silly, backward-looking, patron-
ising and unrealistic, especially in Britain, and some
of them just boosterish in the way we associate with
entrepreneurial therapies. 'Authentic' cuts both ways
politically. Leftists see the right's marketeers as dishon-
est and inauthentic, callous careerists now rather than
patronising toffs. The right, especially the American
right, has demonised the left as liberals, theory-driven
intellectuals who don't know they're born, and certainly
don't know anything about authentic people. Populist
American politicians go for authenticity every time – like
Sarah Palin's identity as a hockey mom, fisher, hunter,
shooter, cookie-maker and all-round big animal killer.
Inauthentic liberals – like Obama, who studied law at
Harvard – just don't get it, say the rightists.

Part III

Who shall we blame;
what can be done?

Who shall we blame?

Authenticity is the new 21st-century fraudulence. I blame absolutely everyone, but especially:

'Marcoms'[46] – the trade-word all the lovely, persuasive, outsider businesses and individuals call in to make themselves look better. They've developed the rhetoric of authenticity to get their clients off the big post-2008 hook of public distrust. All of them phrase-makers, some of my best friends among them.

46 Marketing communications, advertising, PR, digital messaging etc.

Everyone who, 'educated beyond all instinct',[47] ignored the evidence of their own eyes and ears and fell for a variety of scams designed to extract added value from an impressive back-story attached to an underwhelming product. That means, of course, the army of first-time graduates who wanted to show off by adopting 'deep' musicians with big ideas, rather than high-wattage performers. Or the millions of newly moderately rich people around the world who jostle for status in the only way you can in emerging places – by buying the real thing, the right brand, the one with the story.

American individualism – anything but rugged, with its religious undertones, its daytime TV overtones and its very soft options. The world of 'me' and 'my journey'. And Oprah.

Gwyneth Paltrow (I think). I'm working on the evidence there.

47 This was one of Julie Burchill's favourite descriptions for bourgeois intellectuals.

Myself – for suggesting to a soup-maker client that he should make his tinned soups look more authentic, more farmers'-markety, by cutting the vegetables in a more free-form way. At the time, the carrots and swedes and so forth in vegetable soup, scotch broth and similar lines featured root vegetables diced into tiny perfect cubes – so obviously RoboChef rather than rural kitchen (though whatever is done for money is sacred[48]). I was very proud of myself at the time.

Something must be done

'It takes a village,' as Hillary Clinton's caring wordsmith Barbara Feinman said.[49] You can all do your bit. It starts with a self-denying ordinance; never use 'authentic' or any of its little friends conveniently listed here, when a simpler, less inflated, more precise word would do better. Use 'real' or 'fake'; 'true' or 'false'; 'believable'

48 Quentin Crisp.

49 *It Takes a Village: And Other Lessons Children Teach Us*, Simon & Schuster, 1996.

or 'unconvincing'. Unless, that is, you're absolutely sure authentic describes exactly what you mean to say. Avoid all words with the inflationary God particle in them. For 'vibrant', how about 'lively' (or 'noisy')? For 'creative', try 'inventive'. Are you with me?

If you're a wordsmith, PR, speechwriter, lobbyist, corporate social responsibility consultant, or similar, you'll find your clients are expecting this sort of vocabulary now – and it's probably your fault. You'll have to wean them back off it. Just tell them you're saving them from the ridicule. I completely understand that you need to keep your family fed, you've got to service the loan on your houses, and your work is fantastic fun, but isn't it time for a re-think?

The other thing you can do is challenge 'authentic' and the rest whenever they come up. As in 'what exactly do you mean by…?' Channel your inner Scottish school marm, wade in when you read anything particularly fatuous or pernicious. It's so much easier now – you can blog or tweet, you can be a counter-troll, you can sensitise all your friends and stop them before they embarrass themselves. It could spread

like a counter-contagion, from Stoke Newington to Tufnell Park and onwards to Shoreditch (Shoreditch will take a while, there's so much invested in that bare brick).

Stand-up comedians are part of every modern problem going (just think of Jimmy Carr parking £3.5 million in a tax haven). Their promise of content-free edginess, their thought-through Soho-cum-Shoreditch scruff and Converse All Stars irritates. But they're fast, clever and observant. They have to anticipate their audience's responses and they can put a word out of business in no time. David Mitchell in his stance as a '50s middle-middle-class man, fifty at fifteen, is rather engaging. He does a series of smartly produced YouTube films about words and ideas. He's already done over 'authentic' (with a middle-class conundrum: how to pronounce 'valet' in England) and 'passion' (a series of unlikely ads professing passion for ridiculous callings). Get your stand-up friends – research shows that one in five sixteen-to-twenty-fours has some stand-up experience – to do over a word a week. It's your civic duty. See below for the hit list.

I'm a very caring person, and one of my little pleasures in life is changing people's minds for them in a responsible, adult and thoroughly consensual way – people who come out with insecure and arbitrary judgements posing as moral absolutes or commercial buzzfeed got up as eternal verities. It's a little challenge for me – you have to imagine friends grabbing my arms and saying 'He's not worth it' or 'Lighten up, she's awful but she's really fragile'. I won't do it if there seems the faintest chance of injury to me or of pushing them towards self-harm and the Priory.

Otherwise, I'll have a go. And recently I've found myself increasingly drawn to people who say things are authentic, better still, that certain people are authentic or, best of all, that they, their personal, irreducible, throbbingly real selves, their absolute cores, are authentic. I want to give them a modest workout.

The last doesn't happen in Britain all that much. It's still mostly Americans – populist figures like Sarah Palin and Michele Bachmann ('people like me because I'm authentic') or people who turn out at difficult hours to share their heart-warming journeys and high-five

Oprah, who's all heart (I think that's the basis of her famous weight problems – she gets positively engorged with empathy and it puts on pounds overnight).

It's a challenge to the market researcher in me to chase down where the authenticity claim is coming from – a natural attraction to new verbal buzzfeed, insecure snobbery, or blood-and-soil feelings. (A sociologist recently denounced Radio 4's *Gardeners' Question Time* as thoroughly racist. He said the audience's obsession with rooting out immigrant plants or pests, from Japanese knotweed to the black bean aphid, was a racist metaphor.) How can they distinguish the authentic, and what might fake look like to them?

I try, God knows I try, to channel their feelings and a bit of their vocabulary so I can ease them comfortably over via some agreed common ground and onto a slightly different path (the one less travelled). I find the 'inner life' of Gwyneth Paltrow always comes in handy here. I want to leave them feeling 'I'm going to think before I say that again' or 'I'll never look at X[50]

50 Fill in the blank for yourself.

in quite the same way again'. I like to do this sort of thing when well-balanced people who've got a life are planning their Saturday charity marathons or limbering up for a Civil War re-enactment.

Embrace the modern world

Once you've recognised that the quest for authenticity is doomed; that it falls apart under the weight of its own contradictions (just as Marxists, poor darlings, thought capitalism would), and once you've recognised that any claim to authenticity goes straight to fraudulence and ridicule, you can get on with life – and embrace the modern world. The quest for authenticity is a wrong-headed way of trying to create meaning and value – the eternal verities set in ancient stones – as an antidote to the 24-hour wipe of the electronic news cycle, and the ubiquity of techno-fake.

I know Old Spot pork and a 1730s house assiduously restored can be lovely fun (but exactly how far do you take it back escaping into retro-realness – English Heritage has some loopy ideas here), but they're just

more stuff, not the answer. Do you want to take on the 1730 mind-set or the Elizabethan world picture? Obviously not, so why should you even think of archaic plumbing? The first occupants of your house would've adored a 2014 top-of-the-range German kitchen.

The quest for authenticity takes you into some really unpleasant places with some very odd companions. You get down to blood and soil. If you're looking for a stronger flavour than the modern world offers, keep it to pork. Don't buy the loopy opinions along with the authentic house and the fogey wardrobe. You know it's all a game, a dressing-up box, a comfort blanket. Remember the hi-tech, hi-touch[51] formula: as your environment gets more smoothly techno-fake, so you long for a counterpoint – fur, skin, velvet, distressed wood, battered leather, crumpled linen. Just remember that there's an enormous trade distressing, battering and crumpling away for you in Chinese workshops. You

51 John Naisbitt defined the longing for obviously 'real' physical experiences and textures as a counterpoint to the increasingly cerebral 'hi-techness' of modern life in *Megatrends*, Grand Central Publishing, 16 August 1988 (first published in 1982).

absolutely can't win, so don't even try. The moment the word's out of your mouth, like a plummeting denture,[52] it's a dead giveaway.

52 The non-U word for false teeth.